NOT **UPON** YOU

NOT UPON YOU

AN EXPERIMENT IN COLLABORATION
COMPILED AND EDITED BY

ANNE GERMANACOS

Cover art by Elizabeth Billings
Author photograph by Kristin Hoebermann
Art on Dedication page, and pages 31 and 45 by Lola Fraknoi

Cover and book design by Tania Baban Natal

Printed in the United States of America

CONFLUX PRESS
MARINA DEL REY, CA
www.confluxpress.com

This project is dedicated to
the memory of
my mother and step-father,
without whose lives and work
these particular relationships
would not have been.
And to their grandsons, my sons:
May the project act as a hint,
a mirror, a touchstone
as you move forward
in your lives.

מִשְׁנָה אבות ב':ט"ז

(טז) ... לֹא עָלֶיךָ הַמְּלָאכָה לִגְמֹר, וְלֹא אַתָּה בֶן חוֹרִין לִבָּטֵל מִמֶּנָּה.

Pirkei Avot 2:16

(16) ...It is not upon you to finish the work, but neither are you free to desist from it.

FOREWORD

How to combine in a work the freedom of the writer with the privilege of the philanthropist? What compromises are inevitable? Which ones are a bridge? Which might be acknowledged as the work, itself?

While at the Headlands Center for the Arts in the fall of 2015, I began to create a written, collaborative bridge between funder and fundee.

What is this relationship, I wondered? How is each offered a gift? What is taken from each side of the equation? What does the equation, if we can call it that, look like? And if not an equation, how might the relationship be translated into another form?

What does it mean to give? To receive? To take? To offer? To force upon? To steal?

What are the possibilities for change made through the kinds of things that are obviously (and less obviously) exchanged?

Finally: How does helping to support (financially, morally, emotionally) someone else's work feed into one's own work as an artist? And then, conversely: How does one's work as an artist nurture the activist/philanthropist? What is sacred in this circle? What are the avenues

to its destruction? Where does money stop and creative empowerment begin? Where do you stop? Where do I begin? We are, speaking both creatively and spiritually, bound.

So I sent out a letter *(see page 17)*. I asked seventy-one people (sixty-eight are represented here) whose work I admire and support to send me fifteen random sentences or images. In essence, each offering comprised an unusual autobiography, a new take on exchange. I suggested they think of their fifteen random offerings as a version of grant report.

I've used what was given to me as raw material for this book. Something of each return submission I received was processed in my imagination then used as a way of getting back to the origin of things. I requested a contradictory, inconsistent tale. I begged for gaps. I wanted something unmade, with which, possibly, to make (without losing track of making's undoing).

My last book, *Tribute*, explored the nature of consciousness within a single narrating ego.

This project attempts something different: a collaborative experiment

that uses written language to prod the boundaries of ego, juxtaposing mine with yours so that the two (or more) combine to become a whole different from and possibly greater than the parts.

The idea is to resist habits, which form so quickly, and find new ways toward freedom. Collaboration allows a version of freedom different from the expected, when one individual is striving alone.

So this is about the renunciation of the egotism (perhaps narcissism) required to make and be a world unto oneself. This is about the collaboration necessary to do anything in the world, but it's also about the breakdown of the illusion that one is, oneself, everything.

This is a story made of many stories, lines written by many people. I've culled, edited and composed them. But it's only a metaphor for the way any of us lives.

In the non-profit world, language can become automatic and sometimes almost meaningless. My request must have seemed strange to many who received my letter; it was an intriguing one to some. First and foremost, I wanted to offer the participants a different way to

experience time, and then, a different way to connect—with themselves and with the world.

Some were grateful for the need to carve out time to fulfill the request. Others wondered just what it was I was asking for. I couldn't tell them, of course. We could only know once it had happened. This is the iteration of that experiment.

I asked for words and images so that I could make sense of the people and their work in a more visceral way.

I hoped to bring language and silence—the possibility of poetry—to a complex, sometimes fraught relationship, and to complex, fraught lives. I thought of it as a way of resetting or stating a balance and, not least, as a way of undermining the non-profit speak that can render language meaningless and inauthentic.

I've edited the submissions, mostly by cutting, sometimes by changing a word's tense, altering an article, a pronoun, or the position of a word

or sentence on the page. But I haven't added a thing *(see pages 20-22)*.

This is, truly, a very different way of doing business. But—I'm for anything that brings deeper humanity to the necessary exchange of cold, hard cash and its hierarchies.

While I thought this project would produce an objective correlative for the work and the relationships, what it became was a way for me to metabolize, in some sense, the people who do the work. In editing their requested random sentences, something of each was imaginatively ingested. It couldn't have happened without the request and the subsequent offerings, which I think of as a kind of sacrifice, but one akin to a lock of hair rather than what's been done in the past with a ram, bull, or a human virgin.

My imagination had been stopped at the gates, an impasse between one and many lives. That impasse can be thought of as a failure of imagination, lack of nerve, or perhaps simply the sign that I needed to step away from the trail, onto thin air. I was no longer able to seek the truth of the other in an imagined embodiment of my own making but had to seek the truth of the other through their own

representation. Now—consumed, digested, metabolized—I know them, *you*, anew. And perhaps this new knowing is a type of flying, a mode that's required in this work where everything can sometimes seem entirely wrong.

And so, a unique take on exchange—my offering, different from money, back to you.

The process of writing down fifteen random things is a form of mindfulness. You gather and deposit your thoughts, your things, one by one. You become aware of the richness, the endlessness of a mind. It's a form of wealth.

Alva Noe, a professor of philosophy who focuses on theories of perception and consciousness wrote: "Art displays us to ourselves, and in a way makes us anew, by disrupting our habitual activities of doing and making."

Elizabeth Margulis, whose research investigates the dynamic, moment-to-moment experience of listeners without special musical training, wrote: "Part of the aesthetic orientation is a perceptual openness, a

willingness to notice and believe in connections and meanings that may not be instantly apparent."

Where are the gaps, what is the undigested material, the unexperienced life, the trauma at the heart of funding and the people who receive funding? Isn't money always the elephant in the room? How to approach it? How to walk in blind and fathom this giant, coarse-haired silent thing?

I appear to have what you want. And yet, you have what I want. But what I desire is not eternity, fame, or wealth. What I want is to remain alive in the dynamic, by virtue of our keeping it vigorous, spry, generative.

The poems and entries on these pages are made from words elicited in the interest of creating links, sparks of exuberance in a relationship where money tends to set hierarchies and power formations that rob us, giver and recipient, both, of our humanity.

Here I am trying desperately to make a different declension of the noun, money, to invent its possible meaning as a verb. So, perhaps,

this is a different version of the elephant, no longer quite so silent, nor trumpeting, and less hairy. What is the sound of an elephant's breath? This is an attempt to go beyond the usual measurements and limits, putting this relationship, which is, in some sense, sacred, back where it belongs, without, of course, ignoring time's emergency.

What is the trauma at the heart of a relationship based on money? The fear that humanity will be turned to stone. Gold, too, is a kind of stone. We've all experienced our Midases.

As you work an alchemy on money, so I work some alchemy on the words here, taking them for my own, and giving them back differently. A collaboration. An inquiry into the finite and infinite, gratitude, relationship, and the ever-unique individual.

So I ask again: What is a self? Where do you stop? Where do I begin? Here we are, sometimes akin to one.

— Anne Germanacos
San Francisco, California
September, 2016

September 12, 2015

We have been through some form of adventure together, most formally in the roles of grantor/grantee but more richly described as relationships, many of which have slid (risen) to friendship.

As some of you know, I will be an artist-in-residence at the Headlands Center for the Arts for five weeks in the fall (beginning October 14th). While there, one of my proposed projects is to create a collaborative piece that will articulate and embody some aspects of the process that led us to the moment where our lives crossed, then coincided in some way.

Some of you have participated in or been aware of the writing "workshops" (experiment would be the more apt term) I've led over the last few months through Kahini, Alliance for Girls, the California Writers Club, Seeds of Peace and Division 39 (the psychoanalytic division of the APA). In each gathering, I attempted to create an environment that would balance individuality and community. This space, begun in the physical, moved to the psychological and found form in a series of collaborative written pieces. To my mind, the achievement is in the process at least as much as it is in the final work.

I would like to try to create something along these lines but across barriers of space and time.

Are you game? It shouldn't be onerous. What I'd like from you is fifteen "things". These may be all or mostly sentences. Images, sound bytes or short videos are welcome, as well.

In the workshops, the aim has been for RANDOM sentences. I have given people twenty minutes to put down 25 unrelated sentences. (As you'll see, "aiming" for the random creates problems of its own. This is part of the exercise, part of its richness.)

This is not something you should spend a lot of time on. If you can take twenty minutes to jot down some sentences, words, maybe add an image or two—whatever you like—that's all it should require. Just fifteen things. Numbered. **It is not my intention that your list of sentences/things should relate directly to the work you do.** I am hoping to create an embodiment of relationship, not an exact replica. Aim to get lost. What's found may be surprising!

In the workshops, we began with some of the participants reading their sentences aloud. Then, I handed out scissors and people cut their sentences apart, shuffled them around, traded. Each participant ended up with a small pile out of which an order was created. The results were funny, serious, moving, odd. Not a single one was boring. The method released potential which is, at the most fundamental level, what I aim to do with my work as a funder.

And now, an additional, more abstract explanation:

In our work together, money was exchanged. It was not my money. But it was put in my trust and I've tried to put it in the world so that it can become something other than money. (Money is only potential if looked at in the right way).

Your work has enacted a form of alchemy, turning money into something with the radiance of gold. What I might try to say about your work can never be more than a faint sign of what it is and does. I've been frustrated by my inability to enunciate the precise emotional and spiritual configuration of this relationship and its echoes in the world. Through this proposed project—a composition made of parts from many lives—I hope to relay something of that richness and unspeakable beauty. Thus, this invitation to take part in an experiment, a collaborative collage meant to break open traditional forms of writing and

composition as well as to mark the way relationship requires ego while extending beyond it into new realms. One plus one equals a greater one, or an intimation of infinity!

I welcome your feedback and hope you will consider taking part in this project. I'm utterly grateful to you for the work you do and hope this request will spark excitement!

<div align="center">

With all my best,
Anne

</div>

Additional words on the project:

Anything at all. Sit down for twenty minutes and write down whatever passes through your mind (or write down a line each day for the next fifteen days). Anything that occurs to you. From the profound to the (apparently) trivial. A line of Torah. A worry about a parking meter, or the world. Something delicious you ate recently or haven't eaten in years. A description of what is in front of your eyes. Quotes from anyone at all.

In essence, I've asked you for a gift of time and attention. It's an offering (a sacrifice). The words (or images) are an indication of something passing between us. I'm asking for fifteen "things", hoping that the task of cutting into the time of your day to gather those things will change your sense of time, even if infinitesimally.

So, I'm asking something of each of you which I hope will also offer you a small gift.

1. What or who should one become to survive the depredations of society? A fox or a lion?

2. Debt and death. Debt is death? Does debt turn the unknowability of the future into an unavoidable end?

3. Mistrust and fear are public affects and we are mere bearers.

4. Is mourning keeping the memory clean and proper? Is that why it begins by keeping the place of the abject body clean, shiny, and noticeable for others? Lighting incense to mark death, or connecting the physical world with the spiritual, the idea of mourning as cleaning, or as means to re-establish some of those ephemeral ties that we hope to maintain.

5. Landing in yet another American town and all the comforts of everyday life do not ease the feeling of groundlessness. I'm floating and I want to jump or fall to feel the gravity of life.

6. What's the point of teaching Capital when your students read it as failed prophecy?

7. Returning home to talk to strangers. They might reveal more about themselves than the familial ones.

8. The magic of the question.

9. H.L. Mencken had another quote specifically about school learning (conformity and ignorance), but thinking some about the arrogance of teaching and judging: Mencken called judges "Law students who mark their own examination papers."

10. Our relations with cats and other semi-feral or even wild creatures encountered on the margins of cities: birds, deer, coyotes, raccoons, possums and skunks. Urban adaptors, all of us

11. Human public intimacies, launching boldly at times into now intense confidences and sharing: on buses, rideshares, in a semi-random encounter with a friend of a friend, or a total stranger at a park or graveyard.

12. The overlap across, as well as the oscillation between: fatigue and work.

13. Thinking about how art works (and sometimes doesn't) words or images as fragments that can serve as building blocks for something larger than simple accumulation, or as mere isolates.

14. Image of Boy outside Jewish Cemetery superimposed on fountain pool reflection

15. Image of Greek Graveyard Worker and Mourner Cleaning

Nothing you write could possibly be stupid.

I do not think now is the time to withdraw...our alum can handle the rage and need to hear it.

I want to know more what he means about being torn from the inside.

The conversation is barren and brittle.

The tearing is natural, and will heal; it sounds worse than it is.

Are we pissing in the wind? Have the bad guys already won?

Radical inclusion leads to engagement and belonging not diminishment.

Yona, I am really worried.

The talking heads keep on yapping.

But how are *you* holding up?

Violence and the holy. or: title?

Can't, I'm meeting a divorce lawyer.

This is your sister Nechama with her 2 children Velvele and Brohale

This is your mother

During good several years I used to go to him to ask the address, until finally, after hard and long suffering on my behalf, did he agree and gave it to me.

I can't believe what I didn't know, I can't believe I blamed them

On second thought, maybe he actually named our family after the street.
Zamenhof's mohel

images.

Many of my phrases are stolen

(Proof that I'm a bad mother:
I said: Get the fuck in the car.)

On the verge of what?
Being known, knowing.

All here together?

"....and also, a Palestinian dream"

Like Greenpeace: tiny boats that go after big whaling ships.

Maqloubeh with the Rishmawis.
A dream on Star Street in Bethlehem.

"It is our light....that most frightens us."

**The habit of expression leads inevitably to the search
for something to express**

One man's ceiling is another man's floor.
The rain in Spain falls mainly on the plain.
May all your children wake up one by one.

Forfeit your sense of awe,
let your conceit diminish your ability to revere,
and the universe becomes a marketplace for you.

Halas.

The idea of writing down whatever comes to mind

is horrifying.

I don't think you want to know that mayonnaise is one of my favorite foods or that I find corn fed beef superior to grass fed or that unblended scotch is too strong for me.

Apologies and love.

awfully grateful that when I turned 17, my parents gave me a banjo

I make an effort to keep hearing the voices,
but there are voices I've lost.

Are people forgetting how to read?

Growers above Cloverdale were waiting to pick.
The next day those grapes were covered in ash.

I don't sleep enough. It's a problem.

We read of Abraham's near-sacrifice.
(Unmoored since my father died.)

Singing lifts.

Do you believe in XXX?

bio-euphoria is an invented word

half the earth's surface—now that's a lot of real estate

people who live in Finland worry about falling off the edge

Are you a proponent of kids kissing pigs and cows?

dive into a giant pool of DNA

always willing to be wrong

I open my eyes to a circus of politicians

I shut them.

The antidote to pain is numbness:
Numb enough?

Molested, beaten, sold.

I have ploughed and planted, and gathered into barns.
Ain't I a woman?

Nothing more to say.
Thank you.

In my dreams

I am constantly feeding people—cooking food,
chopping it, washing it, handling it, forgetting it,
piling it on tables, trays, paper plates,
in the oven, in the cupboard.

After two years of living between houses and a year settled in one,
I still wake every morning with a question: Where am I?

Stuck.

until every mother knows her child will have
the lazy pleasure of the farmers' market

I don't have time to be strategic
tell the plan to anyone who will listen

(I was the one who had to explain what an anus is.)

Looking for a good mirror—

Are they cracks or wrinkles?

Power is not in the volume

I sing
to hear the voice beyond what can be heard.

the higher it goes, the deeper

Touch the path between.

Invented and reinvented

Cured forever of putting my imagination to work.
Involved in a new project with a grand(iose) title.

Being a professor is anachronistic.

But can't believe some say:
"I'm deadwood and know it."

"Long walks and intimate talks"

Her daughter told her,
while they were sitting next to each other at dinner,
that she misses her mother.

new footage of an atrocity

cat purring
head resting

In pre-dawn darkness, unable to find words.

Is there anyone who is not ambivalent?

Suddenly exuberant, articulate and loud.

It makes sense that high temperatures make wildfires burn faster

My friend, Diane, believes that beets are better as art than as food.
Would the Comma Queen approve?

My garden:
everything from scratch and overly creamy.

politics: hard to resist, disappear in a matter of minutes

Six miles through the air,
didn't die until they hit the ground.

But I don't really understand why.

I'll never forget the look of surprise on his face
when I said, "I love you."

Keep rewriting the mission statement.

We have been on this road forever

Sometimes it feels like a minute.

In the middle of a burnt forest,
the horizon is dark with charred trunks.

It takes a hot fire to release new trees.

Even though it's temporary we still have to make it beautiful

How much is too much or is that the wrong question altogether?

Every day I think, "This is the day."
Without giving up on what could be.

Anyone can come in, that's the whole point.

Bind yourself to others, then lift.

**What they wish for,
deep in their hearts**

An amazing concept.

Frustrated, disillusioned, tired.
Sad.

An electronic oud!
Another universe?
Another stabbing.

Winter: *Egalité, Liberté, Fraternité*

Friends with the director, with whom I share migraine headaches and Tibetan Buddhism

Books—my shadow, my arms

Translating the untranslatable: the Hmong language has no concept of "if."

Just wrote and deleted a sentence about a crisp blue sky at high altitude. Poor syntax.

Because the sky really is crisper at altitude.

Sentence fragments convey immediacy—
A sly dash!

Fingers moving, clicking.

I love Jerusalem in the fall

Arab-Jewish soccer: their willingness to take chances
nothing short of miraculous.

I have to admit:
shocked that he eventually said yes.

With a delightfully knowing smile,
equivalent to a wink,
he agreed to put his tooth under his pillow.

My heart breaks.

Honeymoon in New Orleans

Liberty enlightens the world

Lennon or McCartney?
Worry everyday
(I still buy records.)

New Orleans flea market
A strong cup of coffee

Yesterday, John Lennon would have turned 75.

Called to this grove outside the ancient gates

We've brought our necessities.

Can't wait!

The ocean my garden,
The waves my clock.

Wild rice and currants
The signal goes out.

Fifteen

Filth and steam
Fish ice cream

How does one politely eat lunch during a conference call

All the usernames and passwords,
not to mention the ones that have to be changed every three months.

Who drinks all the Diet Peach Snapples?

A bicyclist throws a cone at a car that nearly hit him.

An office in the basement:
Quiet but isolated.

The weather forecast: useful as playing the lottery.

The conversation: barren and brittle

I want to know what he means:
"Torn from the inside."

Are we pissing in the wind?

Radical inclusion.
Violence and the holy.

But how are *you* holding up?

Mental illness

Elephant herds
Syrian refugees

Drought, melting ice caps, rising seas

Donald Trump?

Earthquake kit

What is enough?

A woman in England makes music from
electric currents generated by plants.

"Empathy.....is made of exertion...." *(Leslie Jamison)*
"Feathery lightness and bolts of iron." *(Virginia Woolf)*

Stuff gets taken when you're living on the street.

A wooden floor

a wooden chair
an ottoman

needlepoint pillow

Surprised by a hat rack?

City scene over the toilet.
Wide bench under a tree.

Soft broom.
Sharpened knife.

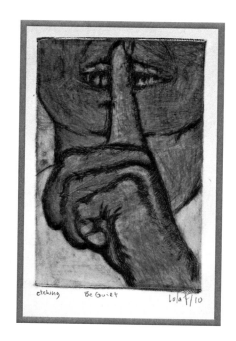

I avoid the news

Just want to eat cheetos.
Focus more on my work?

Wait to buy bedding until my next paycheck?
Not really loving the book I'm reading.

Didn't close the package and now it's hard.

Depressive?
Eat too much cheese?

He's difficult, often jealous, at once generous and passionate.
Love forever?

She's wringing her hands

something's crinkling
gentle shaking

my eye itches

Highlights

harvesting and eating the last summer tomatoes

a survivor from Lodz

walk to work under the drizzle

my new granddaughter's laugh

dinner in the sukkah

vigorous discussion

Syrian refugees

candles in the chilly evening

morning prayers

Checkpoints

Soaring, heady, excited.

Till I realized I really should stop running.

Yearnings.
Creeping fear.

An occupied homeland.

Touch someone's hand.

People killing people everywhere.

The udon noodle shop by the sea outside Barcelona

Before Spain, Amman,
before Amman, Jerusalem,
before Jerusalem, an island off the coast of Turkey.

I sit with my udon noodles.
I read the news.

"The elephants fight and the grass is destroyed.
We are the grass."

Sharing money to make this world more just:
How can I get this across in a power point?

Mountain passes are surely treacherous

tulips in bloom
hot lizards gambol
rhubarb
pickles
trees and their dendrites

Detritus and compost, now and forever.
Jupiter, Saturn and Mars abide.

This is your mother

This is your sister Nechama with her two children Velvele and Brohale.

I can't believe what I didn't know.

I love the economy of fairy tales

"The wife of a rich man fell sick…" *(Cinderella)*

"As she watched him go down the avenue she wept…." *(Edna O'Brien)*

"But when the children came at the weekend……it was hard to find the right moment…" *(Lydia Davis)*

In a pocket-size leather-bound edition of Shakespeare's sonnets,
my father had folded the page at #29:

"When in disgrace with fortune and men's eyes…"

I love paring down, throwing away.

Watchful, hopeful, banal

two friends sharing stories over eggs and sweet potatoes

a broken heart
the sore that happens on a baby's lip from breast-feeding

elation and wonder
(hope and mourning)

Thinking in the shower

no devices, no distractions

if we celebrated birthdays by honoring the one who gave birth

Chinese, Mexican, Middle Eastern
coffee and mint chip

Not good in extreme weather.

Rebellious, creative, nurturing. At times uninspiring.

Too much stuff.
Not enough time.

Hot, or cold?
Notice!

The magic of the question

What's the point of teaching *Das Kapital*
when your students read it as failed prophecy?

Mencken called judges "Law students who
mark their own examination papers."

Return home, talk to strangers.

Birds, deer, coyotes, raccoons, possums, and skunks

urban adaptors

ephemeral ties

fragments that serve

public intimacies

fragments that serve

The students on their work:

comfort
struggle
fight

field of flamingos
Technicolor deer
a body and a car embracing

Embracing!

endless
struggle
comfort

life in an old photo
force in ink

Cacti, twinlike side by side

rain falling
window open
seagull feathers
flock of balloons

According to the New York Times

I do not live wisely

Off the grid?
More yoga?
Is she okay?

Humility, the only way.

My daugher wants to be called Joy

I lie when I say it will be ok.

Picked up my favorite towel,
dried my heart.

small lies

In the Old City of Jerusalem

The British soldier laughed,
kicked her down the stairs.

I'm your second cousin forcibly removed!

Oh, mankind

Pinned to the bed:
garnet sunset
sheltering sky

Four and twenty blackbirds
baked in a pie.

My keyboard is dirty

Punctuation?

I think I think all the time
but there are moments that seem longer
than they should.

The brain at rest? The brain in a state of rumination?

**Gerry the hamster,
back in his cage**

Still looking for god.
Threw up five times on the way.

Light—Ayat-an-Nur from the Quran

Knowledge is a form of light.

I pay to have light—
Some have no light at all.

The sun is setting.
pray Maghrib

Enveloped in the love of a temporary dwelling

the birth of a child is the closest we can come
warm, freshly baked challah
The more you give, the more you want to.

5776 beings

According to my husband, the dog is a TransCat.
Say Meow! He tells her.

"Mama, do any of your friends have your EXACT politics?"

No flour, lots of apples.

Jewish shame and all its forms

"The trouble is, once you see it,
it can't be unseen." *(Arundhati Roy)*

"Ours is a tiny, dirty, lonely, frightened, neglected and lovable village;
it's a blessing from God in the summer, and a curse from God in the
winter." *(Moishe Nadir)*

"If you're an optimist, why do you still look so concerned?"
"You think it's easy being an optimist?" *(old joke)*

"....even if I were the Paul Bunyan of the machete I could never hack
my way through." *(Saul Bellow)*

"But how much more miraculous it is to transform a man of flesh and
blood into a mensch." *(Rabbi Israel Salanter)*

The interior wall of this house used to be the exterior

Where is my home?

My fingers have a life of their own,
produce sounds in my head.

Sometimes question myself.
Remain grateful.

Not only Ramallah but the entire occupied territory

Money does not tap into the essence of human motivation so much as transform it.

A woman locked in

Come on, open the door.

He liked to throw stones,
became an opera singer.

The key to the room?

the turquoise lake

a river of light from my soul to yours
cannot wait to meet God

I have a complicated relationship to ants

I take a live-and-let-live approach until,
too numerous....

It makes me think of Rwanda.

Some days so excited about its sheer potential
that I stop in my tracks and marvel.
Plans to compost, ever elusive.

I forget to drink water, which I want desperately

That ski instructor often pushed me;
I'd nearly topple.

My nose was clogged, my tastebuds weak:
What are blueberries meant to be?

She is forever leaving the last ten percent in her cup and after she goes,
I invariably drink the rest.

I want what was hers? Obsessively loathe to waste?

My feet are cold, but my heart is warm!

Geistwissenschaft

the German word for the humanities,
translates as "spirit-science"

My old Latin teacher, a Catholic monk,
would have us sing this song.

I'm not Catholic but
it always makes me cry.

"What I am and am capable of:

I am ugly, but I can buy for myself the most beautiful of women.

I am lame, but money furnishes me with twenty-four feet.

I am bad, dishonest, unscrupulous, stupid; but money is honored, and hence its possessor.

I am brainless, but money is the real brain of all things and how then should its possessor be brainless?

Do not I, who, thanks to money, am capable of all that the human heart longs for, possess all human capacities?"

(from Marx's Paris manuscripts of 1844)

My womb, your words, our moans

my beauty
my soul
your heart

this day
my love
a world

"Writing is eternal."

I had been having a conversation with a friend.

We debated whether it would make a good tattoo
on flesh that obviously isn't
and whether or not it would get us laid.

No idea what eternity is.

At any rate, a horrible thing to get tattooed.

Not upon you

to finish the work, neither are you free to desist.

Is the question mark an inverted plow?

If I have offended you even unintentionally,

please accept my apology.

Have an easy fast.

God posts guard dogs at the gates

Strive to leave
footprints in the sand.

Who will shovel
dirt on our grave?

ACKNOWLEDGMENTS

With special thanks to Nancy Wiltsek, whose early conversations helped prepare me to take up this work with freedom. Our friendship has been sustaining from our earliest days.

To my tiny board for letting me go my own way.

To the Headlands Center for the Arts.

To Jim Natal and Tania Baban Natal of Conflux Press for taking the collaboration to the next level.

And to all the participants, near and far: this project is only a palimpsest. Your work in the world is the thing itself.

Nabeel Abboud-Ashkar violinist educator Polyphony **Caitlin Baggott** educator activist **Sam Bahour** writer activist **Agelio Batle** artist educator San Francisco Arts Education Project's Interdisciplinary Arts Program **Jeremy Ben-Ami** J Street **Elizabeth Billings** artist **Mackenzie Brown** educator Education Outside **Aiko Cuneo** artist educator **Liz Duraisingh** educator Harvard Project Zero **Dave Eggers** writer Voice of Witness **David Ehrlich** writer Tmol Shilshom **Rachel Eisner** J Street **Tamar El-Ad Appelbaum** rabbi Zion: an Eretz Israeli community in Jerusalem **Jon Emont** writer educator Extend **John Esterle** The Whitman Institute **Michelle Fletcher** dancer videographer **Lola Fraknoi** artist **Howard Freedman** San Francisco Jewish

Community Library **Anita Friedman** Jewish Family and Children's Services **Howard Gardner** Harvard Project Zero **Sydney Goldstein** City Arts and Lectures **Dalia Halibi** Dirasaat **Yair Harel** musician cantor New Jerusalem Orchestra Zion Jerusalem **Jordan Hartt** writer Kahini **Toni Heineman** A Home Within **Aamir Hussein** Interfaith Youth Core **David Inocencio** The Beat Within **Jill Jacobs** rabbi writer T'ruah **Margaret Jenkins** choreographer **Fida Jiryis** writer **Brian Karl** filmmaker anthropologist writer **Emily Keeler** San Francisco Arts Education Project's Interdisciplinary Arts Program **Michael Krasny** writer FORUM **Noa Kushner** rabbi The Kitchen **Lexi Laban** Jewish Film Institute **Rachel Liel** New Israel Fund **Albert Litewka** board chairman Los Angeles Review of Books **Mimi Lok** Voice of Witness **Emma Mayerson** Alliance for Girls **Leslie Medine** On the Move **Daphne Miller** physician writer **Sarah Anne Minkin** educator activist **Anne Moses** activist IGNITE **Daniel Noah Moses** educator Seeds of Peace **Cherilyn Parsons** Bay Area Book Festival **Jason Pedicone** educator Paideia Institute **William Pierce** writer AGNI **Chaya Potash Elise Proulx** Litquake **Dan Rothstein** Right Question Institute **Anya Rous** Just Vision **Nadia Saah** Institute for Middle East Understanding **Nadide Ozge Serin** filmmaker anthropologist **Yona Shem-Tov** Encounter **Stephanie Singer** JCCSF Arts and Ideas **Oren Slozberg** Commonweal **Louise Steinman** writer **John Summers** writer The Baffler **Ilana Sumka** Center for Jewish Nonviolence **Cecilie Surasky** Jewish Voice for Peace **Najeeba Syeed** Spreading Seeds Healing Network **Daniel Terris** Brandeis University **Raquel Ukeles** National Library of Israel **Paul VanDeCarr** Working Narratives **Rebecca Vilkomerson** Jewish Voice for Peace **Indre Viskontas** singer neuroscientist The Ensemble Project **Nancy Wiltsek** foundation director **Sam Wineburg** Stanford History Education Group

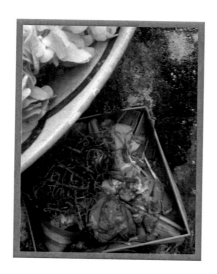